Jon,

You're the first person
I've met from twitter
that I didn't regret
meeting*

Love,

* yet

Oh, the Flesh You Will Eat!

Green Eggzema

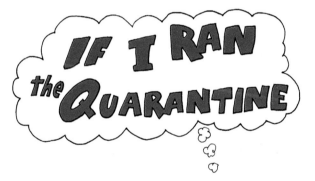

IF I RAN the QUARANTINE

THREE STORIES BY
DR. VIREUSS

Known in certain counties as
"Mike Levine" or "Jacob Vollum"

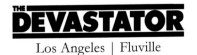

THE **DEVASTATOR**

Los Angeles | Fluville

MORE BOOKS BY DR. VIREUSS

Oh, the Flesh You Will Eat!
Green Eggzema
If I Ran the Quarantine
Hefton Hears His Flu
Hefton Hatches Hives
Hefton Hasn't Moved
And to Think I Caught It from a Vaccine!
The 500 Friends of Patient Zero
McElligish's Petri Dish
The Smallest Pox in Five Blox
Now I Know Hep A, B, C
Star-Bellied Leeches and Other Treatments
On Beyond the Western Nile!
Cubs in Scrubs
Cubs Ii Scrubs Forgot Their Gloves
The Chronic
Happy Half-Life to You!
Contagion and On
The Old Crone's New Crohn's
How the Gritch Got Airborne!
Stomach Bugs Give Inside Hugs
Bartholomu Flu and the Ootbreak
The Out-of-Control Group of Dr. Baloop, and Other Studies

First Edition: October 2015
ISBN-13: 978-1-942099-06-2
ISBN-10: 1-942099-06-1
devastatorpress.com
PRINTED IN ~~MT. CRUMPOX~~ KOREA

INTRODUCTION

What can be said about Antoine "Dr." Vireuss that hasn't already been said by fans, biographers, and the Centers for Disease Control?

Vireuss was a sickly child, and proud of it. He was the bastard son of the county's top surgeon and her suggestible male nurse. Born in Hospital Beth-LMNOP and promptly abandoned to wander the halls because his parents were very busy, Vireuss would not leave the hospital until its renovation twenty years later. Raised by a rotating staff of nurses and janitors, little Antoine became something of a hospital mascot, eventually collecting every condition that came through its doors like lightning bugs in a jar.

Vireuss' life would be forever changed when he was readmitted to the hospital and finally underwent treatment for his many illnesses. It was a decision he would regret for the rest of his life. Always a gracious host, Vireuss cared more for his diseases than the humans he met. He was convinced that humans were the real disease affecting earth, and that viruses and bacteria were people, just like corporations.

Vireuss' chronic depression and intermittent mobility steered him naturally to a career in writing. His first few works were met with controversy, but Vireuss kept publishing books for children until they were universally loathed. His 23 books have been translated into 16 languages, banned, annotated, censored, adapted into screenplays, reprinted, or ignored.

Not much is known of Vireuss' current whereabouts. Some theorize he has moved to an undisclosed life-support system. Others believe he lives in Los Angeles, writing top-notch comedy under the pseudonym "Mike Levine." Anyone claiming to have definitive proof of his current whereabouts has fallen ill under mysterious circumstances.

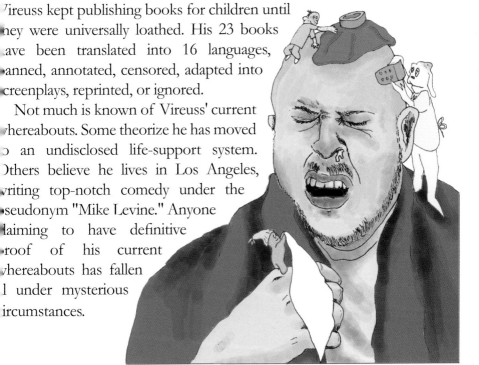

Green Eggzema

By Dr. Vireuss

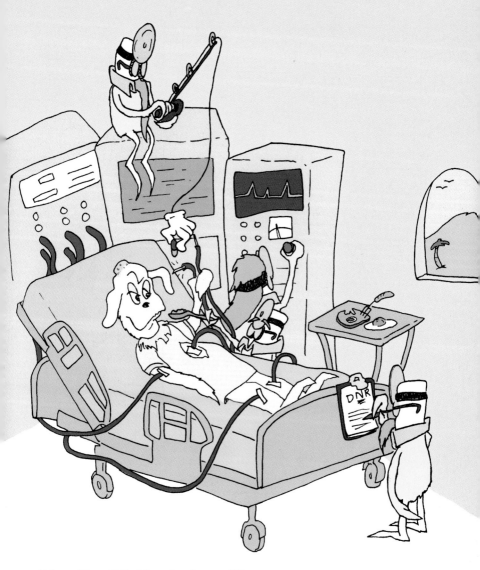

That Dr. Gil, I've had my fill
of Doctors Wil and Bil and Jil!
They brought me here to recommend
removal of my greenish friend.
This spot's what I've got and he's all that I've got.
If I changed then I would be someone I'm not!

You've got a spot that's quite routine.
They're often red or emerald green.
I beg you sir, you've got to stay!
We treat it fifty different ways!

Would you rub it with a cream?
Dry it out, or try some steam?
Would you like needles in your skin?
More or less of oxygen?
Would you soak it in a bath?
Let us graft it with a graft?
Would you like skin sewed on
to places it did not come from?

These procedures may leave you a little embarrassed.
But if left untreated you'll certainly perish!

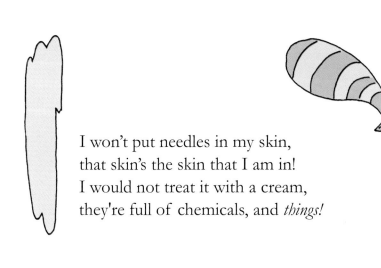

I won't put needles in my skin,
that skin's the skin that I am in!
I would not treat it with a cream,
they're full of chemicals, and *things!*

I do not need a flood or drought.
I'm breathing fine with ins and outs.
My buddy will stay in his place.
right here, adjacent to my face!
This spot and I were meant to be,
I know 'cause it occurred to me.

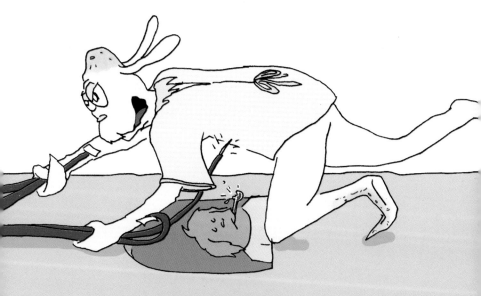

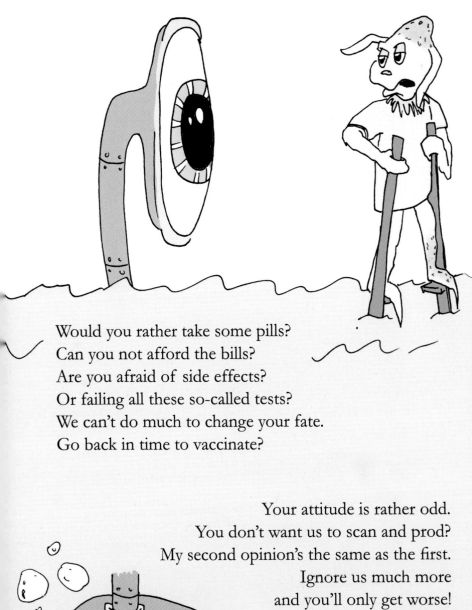

Would you rather take some pills?
Can you not afford the bills?
Are you afraid of side effects?
Or failing all these so-called tests?
We can't do much to change your fate.
Go back in time to vaccinate?

Your attitude is rather odd.
You don't want us to scan and prod?
My second opinion's the same as the first.
Ignore us much more
and you'll only get worse!

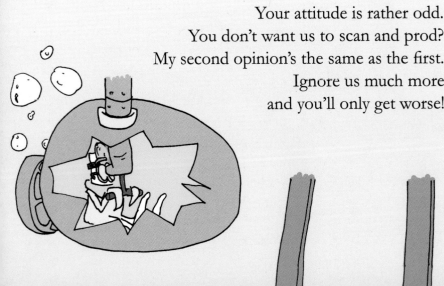

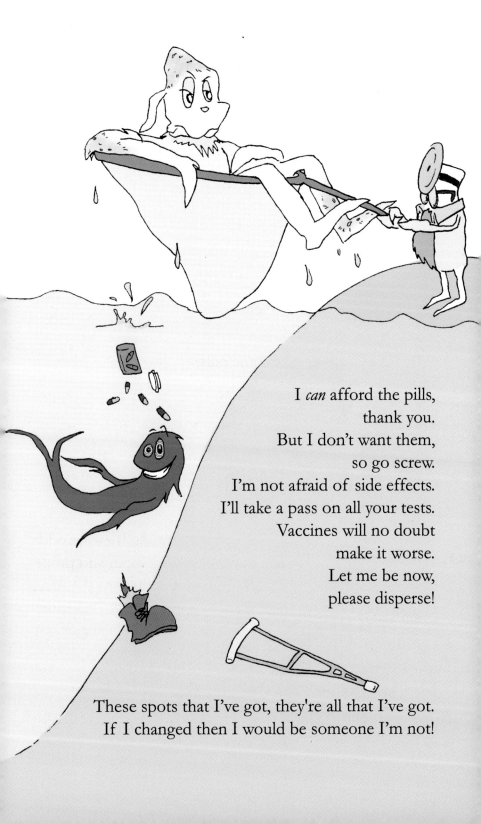

I *can* afford the pills,
thank you.
But I don't want them,
so go screw.
I'm not afraid of side effects.
I'll take a pass on all your tests.
Vaccines will no doubt
make it worse.
Let me be now,
please disperse!

These spots that I've got, they're all that I've got.
If I changed then I would be someone I'm not!

Would you like to face yourself
with psychoanalytic help?
Would you genuflect to pray?
Can we try a nasal spray?
Or massage those toxins out?

Primal screaming?
Modern shouts?
Endocarterectomy?
Shocks with electricity?
What you've got's a breeze to treat.
We could do it in your sleep!

No to bandage, no to cast.
No resorts from first to last!
No to ice packs, no to hot.
Medical nor neti pot.
No to yes, and no to maybe.
No to stem cells, they're for babies.

No scan or scams or screens or schemes.
It's easier to just stay green!
These spots that I got, they're all that I've got.
I won't let you change me to

someone

I'm

not!

We still do not think that this is for the best,
but maybe just once we'll do what *you* suggest.
Our oath is to meddle, intrude, interfere,
but we'll try something new just by leaving you here.
A bold new procedure, with *no* sorts of features.
We'll try it for measles, and lupus, and fevers!

Your body is yours,
we're just getting that now.
It took a real hero to show us just how
your spots have got you
more than you've got your spots.
We won't try to change you to

someone

you're

not.

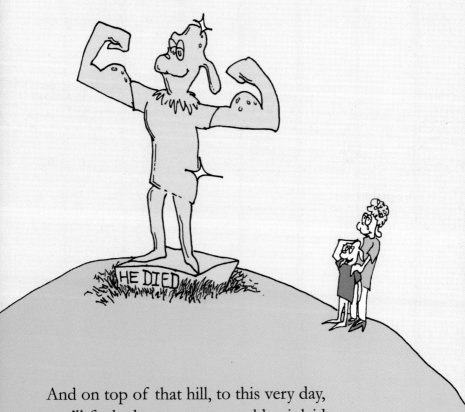

And on top of that hill, to this very day,
you'll find a bronze statue, golden inlaid.
And all of the doctors, every last one,
remember that guy who had stuck to his guns.
You'll uncover a quote if you brush off the dust:

"HE DIED WITH HIS SPOTS ON,
WOW, HE SURE SHOWED US!"

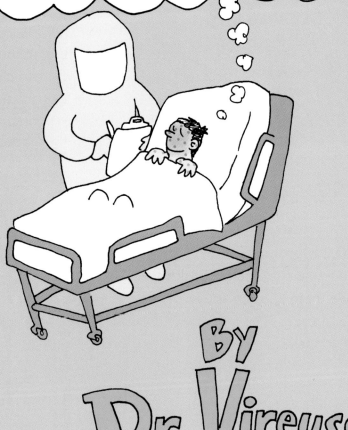

If I ran the quarantine,
here's where I'd start:
I'd capture the strongest,
the fastest,
most smart

I'd find all those sickos
who run marathons.
Cut 'em off at the pass,
so they won't run for long

I'd make sure they're healthy,
give them all their shots,
Then lock them up tight
in an inside-out-box!

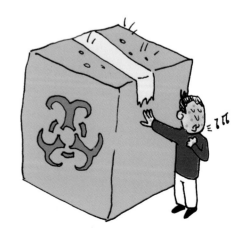

If outsides are insides in inside-out space,
my quarantine would be all over the place!
It'd be a big party, a mixer of sorts,
with everyone dancing right out of their shorts!

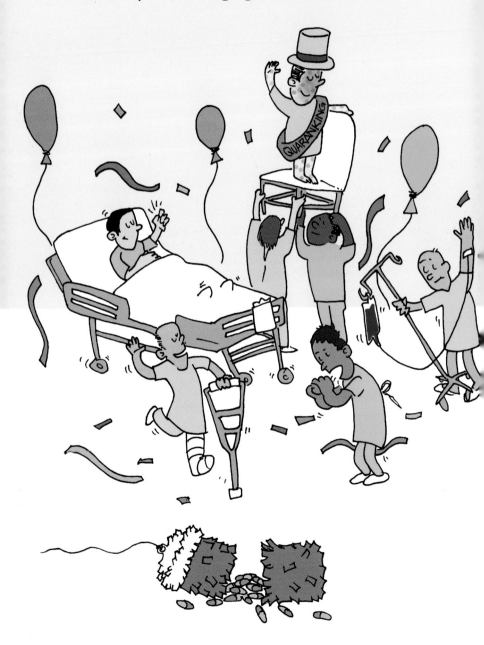

A petri dish is like a big party platter.
If everyone's sick then it just doesn't matter!
The quarantined people will quickly get bored

when they see us have fun
with the friends they ignored.

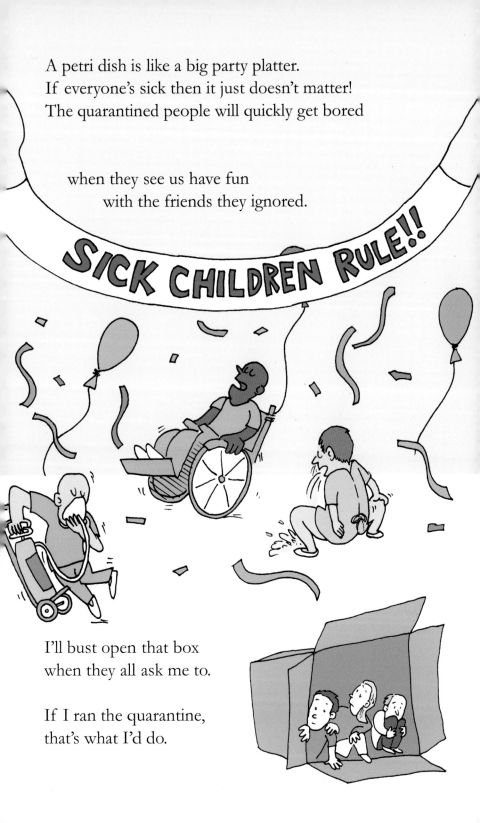

I'll bust open that box
when they all ask me to.

If I ran the quarantine,
that's what I'd do.

Oh, the Flesh You Will Eat!

Congratulations!
Today is your day!
You've infected your Host!
You're off and away!

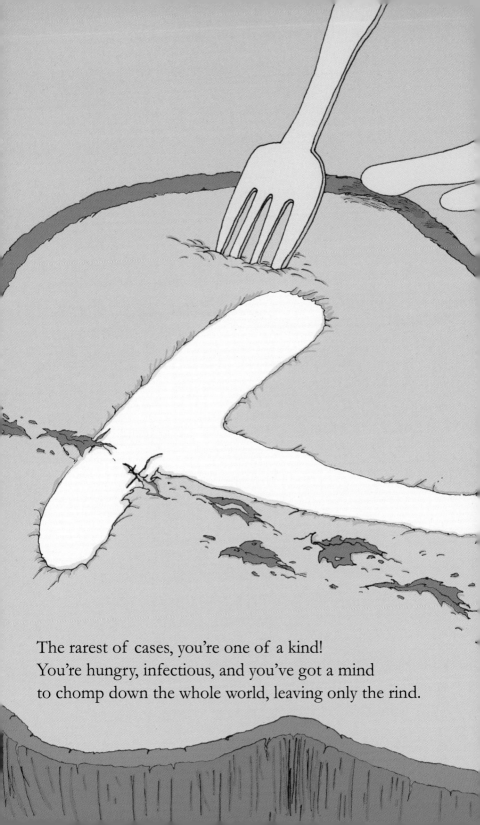

The rarest of cases, you're one of a kind!
You're hungry, infectious, and you've got a mind
to chomp down the whole world, leaving only the rind.

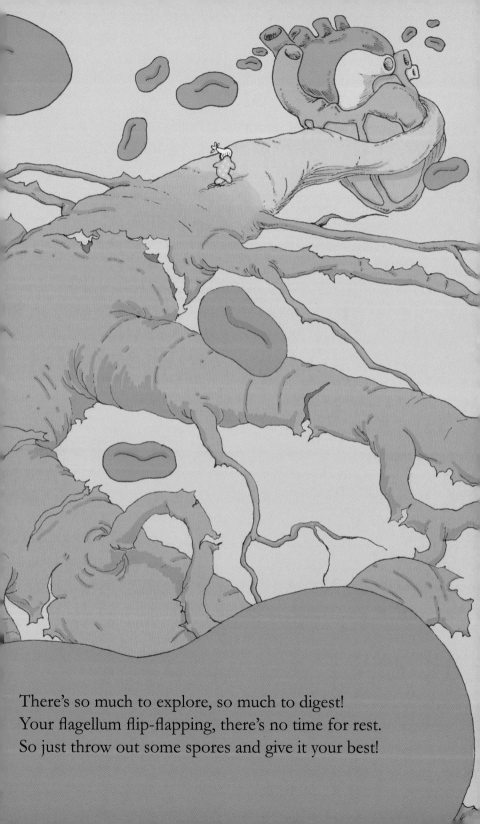

There's so much to explore, so much to digest!
Your flagellum flip-flapping, there's no time for rest.
So just throw out some spores and give it your best!

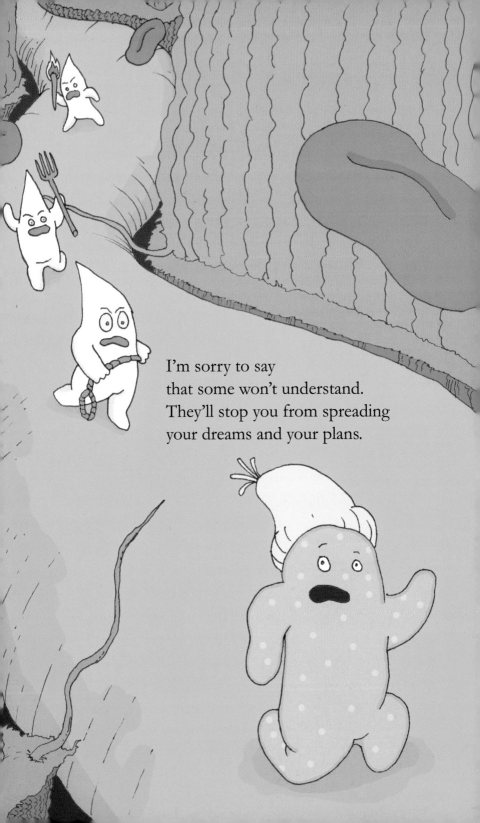

I'm sorry to say
that some won't understand.
They'll stop you from spreading
your dreams and your plans.

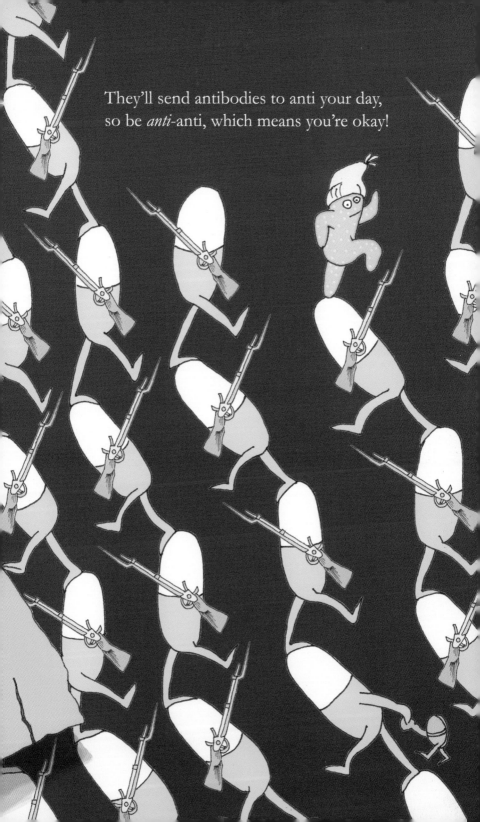

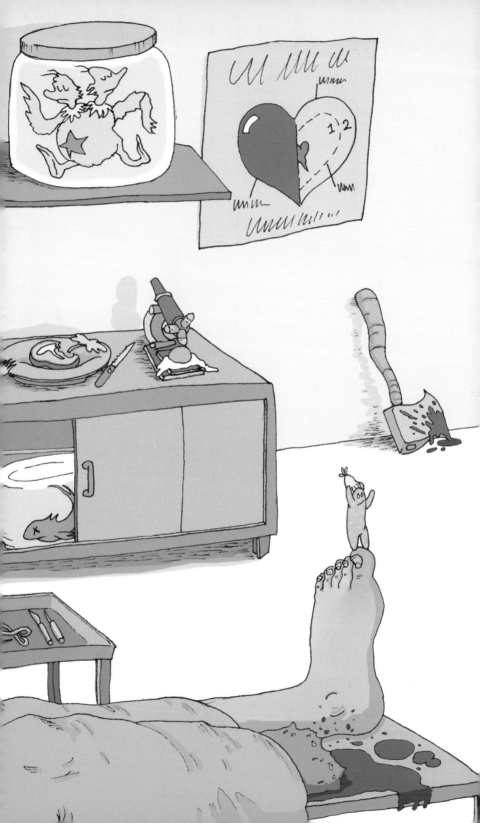

You'll say goodbye to friends,
such a hard thing to do,
but you might still grow fonder of them once removed.

And there may be a chance,
though the chances are slim,
you just won't feel at home
in the skin you are in.

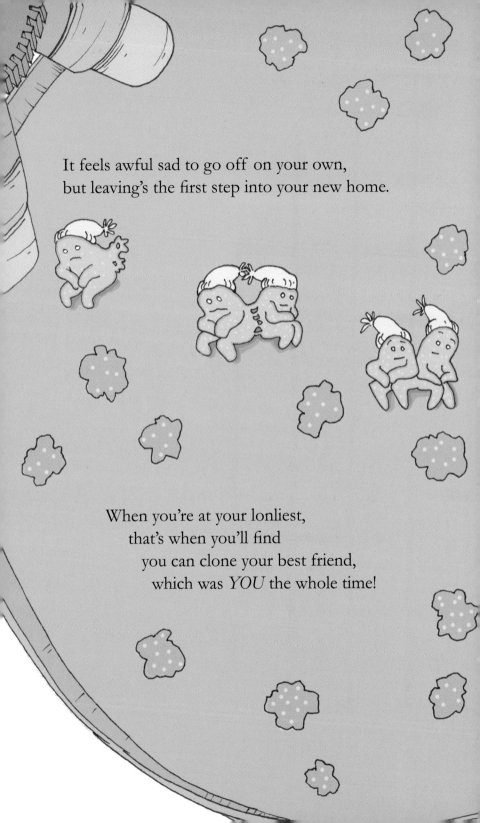

It feels awful sad to go off on your own,
but leaving's the first step into your new home.

When you're at your lonliest,
that's when you'll find
you can clone your best friend,
which was *YOU* the whole time!

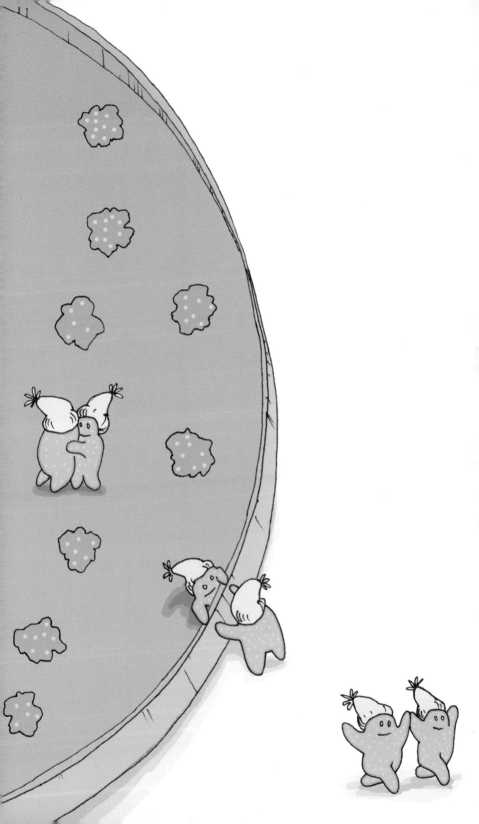

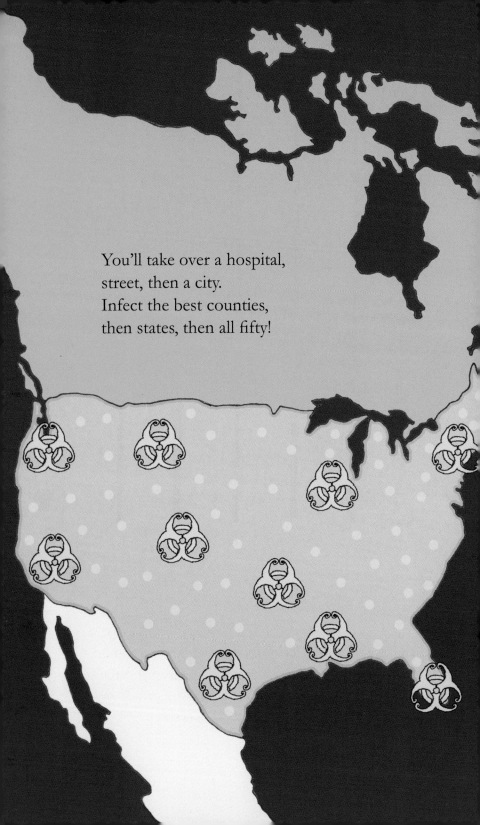

You'll take over a hospital,
street, then a city.
Infect the best counties,
then states, then all fifty!

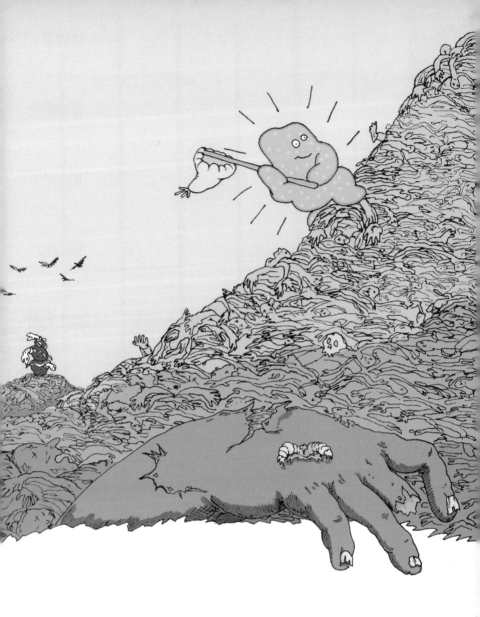

You'll spread across countries at rates exponential.
The world is now yours – but why limit potential?

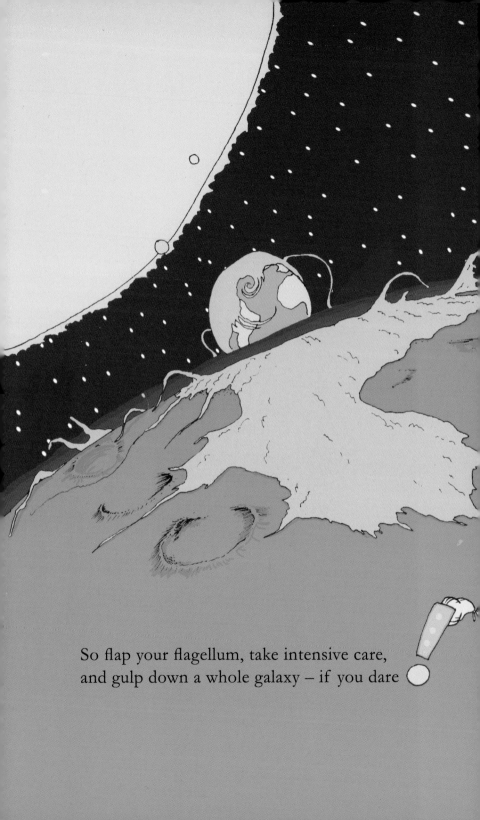

So flap your flagellum, take intensive care,
and gulp down a whole galaxy – if you dare